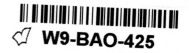

AMERICAN LANDSCAPES

Springs Mills Series on the Art of Photography

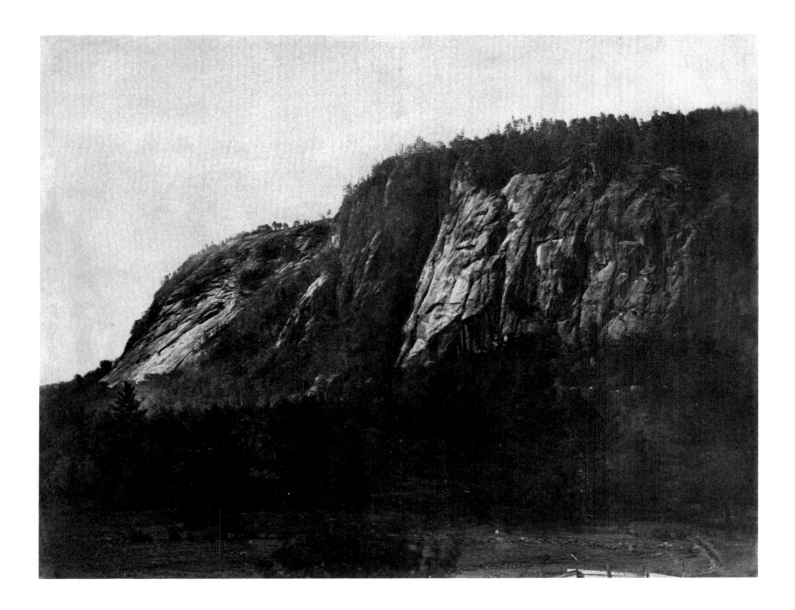

JAMES WALLACE BLACK

The Ledges, North Conway. 1854. Calotype (salted print), 9⅜ x 11⅞ inches.

AMERICAN LANDSCAPES

Photographs from the Collection of The Museum of Modern Art

John Szarkowski

The Museum of Modern Art, New York

Distributed by New York Graphic Society, Boston

Exhibitions in the Springs Mills Series on the Art of Photography
at The Museum of Modern Art
Jerry Dantzic and the Cirkut Camera May 9-July 30, 1978
Grain Elevators: Photographs by Frank Gohlke November 6, 1978-February 4, 1979
Ansel Adams and the West September 8-October 28, 1979
American Children January 8-March 29, 1981
American Landscapes July 9-September 27, 1981

Designed by Melissa Feldman
Type set by M. J. Baumwell, Typography, New York, New York
Printed by Rapoport Printing Corp., New York, New York
Bound by Sendor Bindery, Inc., New York, New York

The Museum of Modern Art
11 West 53 Street
New York, New York 10019

Printed in the United States of America

Like many of the more useful words in our language, *landscape* has proved highly adaptable, and has accepted with grace a wide variety of meanings, including those for which we might alternatively use the words *culture, overview, geography,* or *prospect.* It has also combined freely with other words, so that we speak without embarrassment of the urban landscape or the political landscape. Without disputing the usefulness of such concepts, the word is used here in a much more restricted sense, to denote a family of pictures concerned with two issues: the formal problems of picture making, and the philosophical meaning of the natural site — those places where man's hegemony seems incomplete. Or, one might say that landscape pictures are those that express an apprehension of the difference between our special human concerns and the earth's own compulsions.

We think of landscape pictures as an ancient genre, but it is in fact quite a modern one. It is true that St. Augustine said, fifteen centuries ago, that "We can never sufficiently thank Him for the gift of nature: that we exist and are alive, that we can enjoy the sight of earth and sky,"[1] but for a millennium artists made little use of his sweeping imprimatur, until Alberti and Columbus, the fifteenth century's two great rationalizers of space, defined coherent ways of looking at and thinking about the world. Even then, the art of landscape developed tentatively; and without forgetting the Venetians, or the seventeenth-century Dutch, or Poussin and Claude, it is possible to say that it is not until the end of the eighteenth century that the modern idea of landscape comes to flower. This idea was that the natural site is not merely an ideal setting for beautiful or heroic acts, but that it is in itself a primary source of meaning, and an original pedagogue.

So profound a change was surely impelled by broad cultural needs, not merely by the intuitions of a few artists. Nevertheless, the contributions of those few were so powerful and original that we still cite their names to explain what we mean by the word nature. Not all of them were painters. Before Constable said that he had never seen an ugly thing in his life,[2] Wordsworth wrote, "To every natural form,.../even the loose stones that cover the highway,/ I gave a moral life: I saw them feel,/ or linked them to some feeling..."[3]

5

Perhaps the radical democratization of artistic subject matter that is reflected in Wordsworth and Constable was one of the factors that made possible the invention (or the discovery) of photography. But even if this is not the case, it is surely true that the new medium was well suited to take advantage of the new sensibility. If even the loose stones on the road related to a life of moral feeling, perhaps photography could describe the relationship.

Wordsworth's idea of nature should not be confused with the more recent — and largely American — ideal of wilderness. The central tradition of European landscape painting finally dispensed with mythology, politics, religion, and history, but it did not dispense with man: in front of the wild mountain lay the green pasture with kine or sheep, or cultivated fields, or a road lined with poplars, or — in place of the earlier gazebo or classical ruin — a peasant's house. These pictures celebrated a new sense of cordial intent between man and nature; they expressed the perception that the force of wilderness had been tamed a little, that it was now less terrific, and had become a subject available to the lyric sensibility.

In nineteenth-century America this was a hard point to make. If America had little landscape art, it was perhaps because it had, in the sense defined above, little landscape. American painters could learn the ideal and the techniques in Rome, but once back home they were not easily applied. But for the photographer the problem, if he was aware of one, was even more difficult, for he was limited to what was in fact there, and what was there was for the most part wilderness — from an artistic point of view, chaos.

The problem was not solved but redefined, by men who were not artists in the traditional sense. These were the photographers who during the last third of the nineteenth century photographed the unsettled American West — a country that was, even by American standards, extraordinarily inhospitable to the traditional concept of pastoral beauty. These photographers were, in varying proportion, explorers, adventurers, technicians, and entrepreneurs. Some were men of original artistic talent, but they had not been educated as artists and were therefore without conventional artistic ambitions.

All those in this first generation of western photographers seem excellent to us. William Henry Jackson, Timothy O'Sullivan, William Bell, John Hillers, F. Jay Haynes, Eadweard Muybridge, and Carleton Watkins all made splendid pictures. Perhaps the scale of the challenge and the difficulty of the work filtered out the cautious and the faint-hearted. But of all of these, later photographers have been most impressed, and most puzzled, by Timothy O'Sullivan.

O'Sullivan had been one of the most productive and most interesting of the Civil War's photographers. His pictures describe the simple facts of the conflict — not only the grisly facts of death, but those of the new technology of war, and the immemorial tedium — with a distinctive simplicity and clarity. Nevertheless, his photographs of the war would not lead one to expect his later work in the West, which began in 1867, in O'Sullivan's twenty-seventh year, with the first of Clarence King's explorations of the Fortieth Parallel.

O'Sullivan's function on the expeditions that he served, like that of other photographers on similar projects, was half that of scientific technician and half that of publicist. No evidence at hand indicates that O'Sullivan's work clearly contributed to a scientific understanding of the country he photographed. His work was printed in substantial editions, and it might therefore be assumed that it helped secure additional appropriations for the King survey, and thus prolonged its life.

In any case, O'Sullivan's special place in the affections of later photographers is due not to his pictures' scientific or political value, but to their remarkable originality and formal beauty. It has been difficult to account for the boldness and economy — to put it bluntly, the apparent modernity — of O'Sullivan's landscapes, except on the basis of mutant, native talent, the kind of natural grace by which a great dancer or singer seems possessed. Surely it would be willful and ahistorical to attribute to O'Sullivan — a man who spent his brief adult life on battlefields or in the wilderness — a conscious concern for plastic values. Still, plastic values existed before they were named, and one might argue that along the Fortieth Parallel the landscape was so devoid of human reference, so lacking in the signs of history and philosophy and poetry, that plastic values were the only ones at hand.

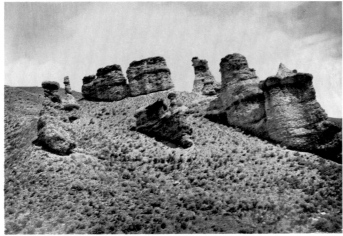

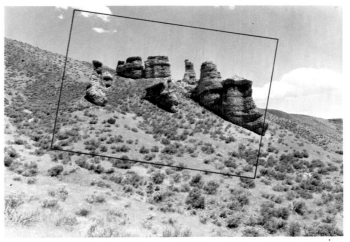

TIMOTHY O'SULLIVAN. *Tertiary Conglomerates, Weber Valley, Utah.* c. 1868. Albumen print from a glass negative, approx. 9 x 12." Collection U.S. Geological Survey, Washington, D.C.

RICK DINGUS for the Rephotographic Survey Project. *Witches Rocks, Weber Valley, Utah.* 1978. Silver print, 9 x 12." The Rephotographic Survey Project, Sun Valley, Idaho.

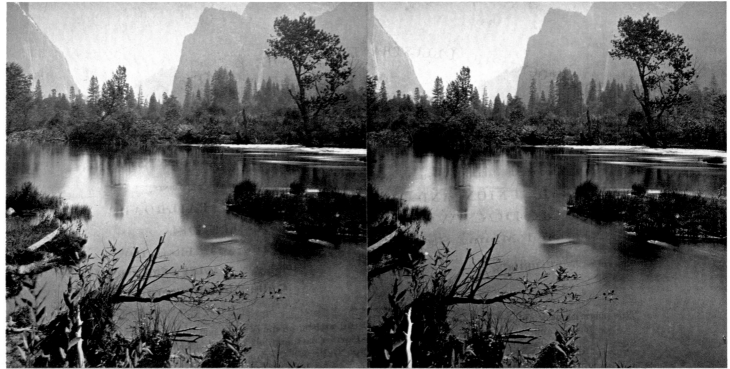

EADWEARD MUYBRIDGE, *View in the Valley of the Yosemite.* 1867 or 1872. Stereograph, albumen prints from glass negatives, 3³/₁₆ x 6¹/₁₆." The Museum of Modern Art, New York.

Whatever O'Sullivan's conscious motives, they did not make his pictures for him; it was O'Sullivan himself who made the imponderable, endlessly variable, hopeful decisions concerning where and when, and in or out, that are the crux of a photographer's art. The way in which O'Sullivan resolved these questions, questions that cannot be answered (well or badly) by a theory, produced pictures that are simple and surprising, poised and full of force.

It has long seemed to this writer that O'Sullivan's genius was necessarily of a purely intuitive order, operating, unknown to O'Sullivan, within the outer protective cover of a simple record-maker. This thesis has been badly shaken by an astonishing recent discovery by the photographer Rick Dingus of the Rephotographic Survey Project, who has found and precisely rephotographed several of O'Sullivan's motifs, including the one reproduced here.[4] Mr. Dingus's picture demonstrates that O'Sullivan made his photograph with his tripod and camera canted nine degrees from the horizontal. This seems an act of almost willful aggression toward the principles of record-making, and is difficult to explain except on the grounds that O'Sullivan found the picture more satisfactory that way.

The early photographers of the Pacific Coast, most notably Eadweard Muybridge and Carleton Watkins, had a different problem from the survey photographers. California was, in American terms, an old civilization; its scenic wonders had been described by the Spanish and later by the Yankees before the photographers arrived. Many corners of the landscape— not great mountains, but details of mountains—had been given poetic names: Cathedral Spires, El Capitán, Bridalveil Falls; finally even individual trees of the great sequoia groves were named: Grizzly Giant, General Sherman, etc. Thus the function of the photographer was less that of explorer and more that of laureate, memorializing known wonders in which the people took pride. It was perhaps a little like photographing the Parthenon: certain understandings prevailed and certain expectations were satisfied. Both Muybridge and Watkins did devise interesting strategies for showing the prescribed motif in a fresh manner. One favorite technique was to photograph the famous walls of Yosemite upside down, reflected in a smooth pool of

the Merced River. This device had the added virtue of providing a more richly articulated sky by filling it with gravel bars, grassy banks, log jams, projecting rocks, and other imperfections in the mirror. (Skies were a thorn in the side of the nineteenth-century landscape photographer; because of the limitations of his blue-sensitive emulsions, the sky was generally either dead or false, and often both.)

Watkins worked much of the Pacific Coast as a landscape photographer, and was thus less constricted than Muybridge by the public's knowledge of what it liked. Perhaps his most distinctive pictures were made outside of the great showplaces of sublime scenery. These pictures are clean and literal, elegant in their technical subtlety, and tactfully respectful of the sovereign rights of his subject matter.

For the photographer the American frontier lasted only a generation, from the end of the Civil War to the turn of the century. After that a pocket of difficult terrain here and there might preserve a sense of the old dispensation for a few decades, but they were vestiges. Darius Kinsey began by photographing one of these remnants, the great pine and cedar forests of the Northwest, and stuck to it without flinching until they had been reduced to boneyards of smouldering slash. Kinsey died in 1940, after falling from a pine stump large enough to hold him and his great spreading tripod.

As the frontier moved westward, other photographers behind the passing front could begin to celebrate nature as a poetic issue. During the same years that the survey photographers described the fearsome West, Henry Hamilton Bennett, a generation eastward, in Wisconsin, made pictures of the landscape as a picnic site: a sweet and not too dangerous place during the good months, adventurous in aspect, but mapped and settled and free of wild Indians.

The end of the frontier was confirmed, or at least attested to, by the rise and success of a new genre of quasi-impressionist landscape photography at the turn of the century. The landscapes of the youthful Edward Steichen, Clarence White, and Alvin Langdon Coburn succeeded in eliminating from the subject every suggestion of harshness and difficulty. In these pictures

there is no bitter cold or cruel heat, no place for snakes or biting insects, no fear of falling, no infinite spaces, no suggestion that nature may be a cruel adversary. Nature has become instead a part of the known habit and syntax of art, like fruit or flowers arranged on the sideboard.

As predictable and codified as most of these pictures seem today, the best of them remain touching and original within the limits of their concept. In historical terms they were persuasive enough to preempt the field for a generation, and convince everyone (except primitives like Darius Kinsey) that this was the way that one photographed the natural site. As late as 1922 Edward Weston wrote that landscape was an unsympathetic subject for photography: it was too "chaotic...too crude and lacking in arrangement,"[5] in effect too difficult to order without resorting to the manual, semipainterly revisions that Weston considered inimical to the true spirit of photography.

But before that decade was out both Weston, in California, and Paul Strand, on the other edge of the continent, had started again on the problem, beginning with the landscape's small parts—a cypress root, a mushroom hidden on the forest floor—and proceeding in measured steps toward the larger chaotic landscape as they learned to recognize and describe progressively complex orders of order. Of the two, Weston followed the problem farther. Gradually he moved his camera backward to deal with a larger and more complex field. Until the mid-1930s he tended to avoid the horizon, or to use it as a beautiful line, a graphic obbligato at the top of the picture, contenting himself with an order that could be managed in a taut, shallow space, almost in two dimensions. But by the late 1930s, when he was at the height of his powers, no space seemed too broad or too deep for him, and he made pictures of the large, complex world that are as clean and clear, as swaggeringly sure of themselves, as his early pictures of the landscape's fragments.

He even made landscapes with modern highways in them. This was during the classic age of motoring, in America a period of perhaps twenty years. (Earlier, in the heroic period, the roads were not good enough; later, after the second War, they quickly

became too good.) It is a minor proof of Weston's intuitive intelligence as an artist that he never learned to drive a car. This allowed him always to be driven, to sit in the right-hand front seat with his bright, light, hungry eyes searching the landscape for the meat of his art, periodically ordering the driver (wife, son, friend) to slow down, stop, back up, turn around. Most of the pictures that he discovered from the car window might have been discovered by a pedestrian, but not all of them. Some of them celebrate the pleasure of being driven down a smooth and empty macadam highway and watching out the window as the picture changed. Imagine his surprise and satisfaction when he recognized that *Quaker State Oil, Arizona* (page 43) was in fact a picture, and also part of his life and his adventure, and shouted to the driver, "No! Back up; the sign is a part of it!"

One might say that Weston was an exemplary, classical modernist in the sense that what he demanded first of his pictures was formal integrity. In 1931 he wrote, "How little subject matter counts in the ultimate reaction!"[6] A decade later he would have said something a little different; his work had become more personal, more richly allusive, less obviously abstract in its construction. But whatever other challenges he accepted, his first goal for his work was perfect physical poise. He could on occasion tolerate a banal picture, but not one that was confused or approximately formed. For Weston it was the independent, impersonal soundness of a picture that made it a work of art.

Although a generation younger, and led by a cooler and more delicate sense of form, Harry Callahan is in this sense similar to Weston. The work of both men is in the philosophical sense functional; it begins with a curiosity about the process—with the question: what can a camera do?—rather than by questioning what is objectively important, or what redolent of private insights. With both men it would seem that an interest in the formal possibilities of the process led toward progressively more adventurous philosophical grounds—that the camera was not simply their tool, but their teacher.

Such a stance, suggesting patience, openness, and a certain modesty of emotional means, is perhaps a useful one for the landscape photographer: a nicely calculated middle position between scientific detachment and self-expression—between, for

example, the landscapes of Dorothea Lange, which seem to speak to a large social truth, and those of Alfred Stieglitz, which seem to claim a special closeness to the secrets of creation.

Alfred Stieglitz — Weston's sometime hero, and perhaps Laius to the younger man's Oedipus — was well into his middle age before landscape became a central issue for him. By that time Paul Rosenfeld had written that, to Stieglitz "there seems to be scarcely anything...that is not in some fashion related to himself,"[7] meaning this of course to be understood as high praise, a tribute to the breadth of Stieglitz's sympathies and the reach of his imagination, not as an accusation of vaulting egocentrism. Rosenfeld's appraisal presumably seemed not unreasonable to Stieglitz, who himself said that he found even in the clouds images that were the "equivalents of my most profound life experience, my basic philosophy of life."[8] There is no reason for us to doubt this; on the other hand there is no way for us to test the claim, since we have no alternative record of this most profound life experience to which we might compare the photographs. So we must finally compare Stieglitz's photographs not to the soul of their maker, but to other pictures, and to our own knowledge of his subject matter. In these terms his mature landscapes seem to this viewer not celebrations but elegies, dense, somber, hermetic, often close to anguish.

If the classical modernists saw the landscape as a lumber room of universal form, and Stieglitz saw it as himself in metaphor, Ansel Adams has seen it as an event, an ephemeral, continuing drama. The protagonist of the drama is the light, which is for Adams not merely the passive medium of sight, but the vital agent that continually renews our experience of the world; and the theme of the drama is the character of a place that seems much like Eden.

The accidents of environment and temperament chose Ansel Adams to photograph those corners of the American earth that look now much like they looked a century (or a millennium) ago, if one is careful in selecting one's vantage point. He has done this so persuasively that it has seemed to most younger photographers of ambition that that book has been closed — that it is not possible for them to make their own photographs in Yosemite Park, for example, unless perhaps they photograph the parking lots, or the funny campers

with their space-age hiking shoes and backpacks. And beyond the question of competition—the ancient impulse of the artist to find his own unoccupied ground—there is perhaps a deeper reason why these younger photographers find it difficult to make new pictures of snow-capped peaks and gemlike mountain lakes: such country is not theirs, not by right of early memory or personal discovery or long travail or habit; it is theirs only in the sense that the objects in a public museum are theirs. One describes such public treasures with a sense of respectful disengagement, and awkwardness.

And behind that, there is perhaps still a deeper reason. We have been half persuaded by Thoreau and by the evidence of our own brutal use of the land that the earth is beautiful except where man lives, or has passed through; and we have therefore set aside preserves where nature, other than man, might survive, and which men may visit in reasonable numbers and with adequate supervision, for their education and edification. This is an imaginative and admirable idea, and would perhaps be nobler still if we locked the gates to these preserves and denied ourselves entrance, so that we could imagine better what transpires there. We could then turn our attention to the rest of the earth, the part in which we live, which is not yet devoid of life and beauty, and which we might still rescue as a place worth celebrating.

This is perhaps what photographers have begun to do, starting with the intuition that one must begin with respectful attention to what remains alive, even if scarred and harshly used, and trusting that attention will grow into affection, and affection into a measure of competence, so that we might in time learn again to live not merely on the earth but with it.

NOTES

1. Augustine *City of God* (trans. George Gordon) 7. 31.
2. Charles Robert Leslie, *Memoirs of the Life of John Constable, R.A.* (London: J. M. Dent & Sons, Ltd., 1912), p. 246.
3. William Wordsworth, "The Prelude," bk. 3, lines 130-34, *The Prelude, Selected Poems and Sonnets*, ed. Carlos Baker (New York: Holt, Rinehart & Winston, 1954).
4. The Rephotographic Survey Project, 1977, 1978, 1979. Ellen Manchester, Director; Mark Klett, Chief Photographer; Joann Verberg, Research Coordinator. Sponsored by the Sun Valley Center for the Arts and Humanities, Sun Valley Idaho, Funded by the National Endowment for the Arts and Polaroid Corporation.
5. Edward Weston, "Random Notes on Photography," *Photography: Essays & Images*, ed. Beaumont Newhall (New York: The Museum of Modern Art, 1980), p. 227.
6. Edward Weston, "Daybooks, March 8, 1930," *The Daybooks of Edward Weston: Volume II, California*, ed. Nancy Newhall (New York and Rochester: Horizon Press in collaboration with George Eastman House, 1966).
7. Paul Rosenfeld, "Stieglitz," Newhall, *op. cit.*, p. 209.
8. Dorothy Norman, *Alfred Stieglitz: An American Seer* (New York: Aperture/Random House, Inc., 1973), p. 209.

GEORGE N. BARNARD

The Crest of Mission Ridge. 1864 or 1865

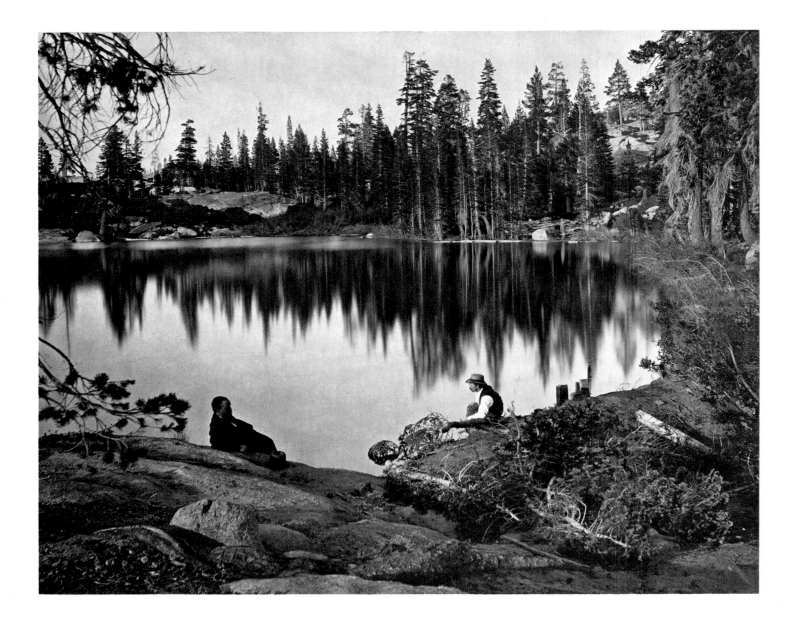

CHARLES ROSCOE SAVAGE

Lake Angeline. 1860s

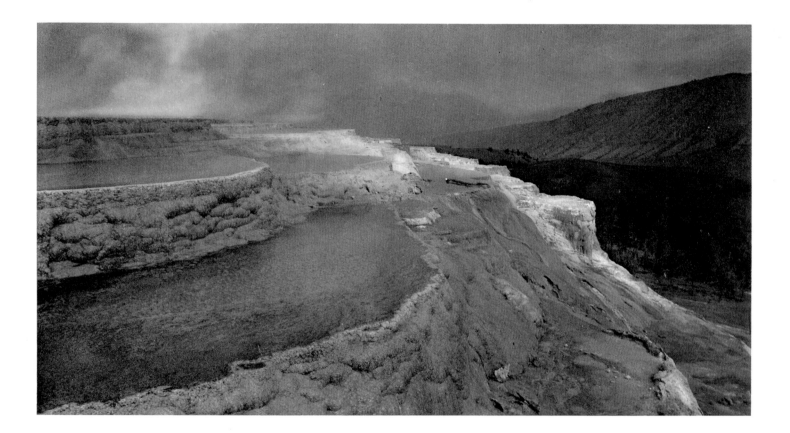

WILLIAM HENRY JACKSON

Mammoth Hot Springs, North from Upper Basins. 1869-75

19

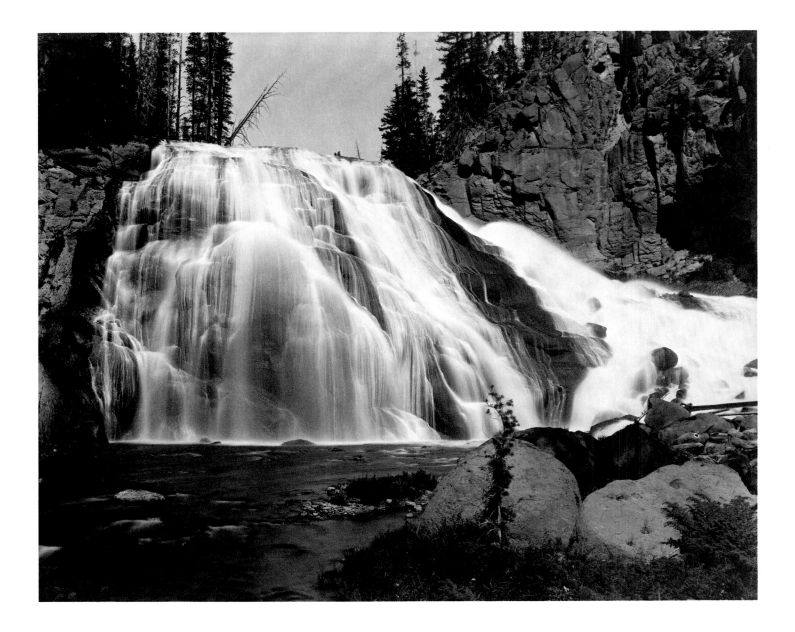

FRANK JAY HAYNES

Gibbon Falls. 84 Feet. Yellowstone National Park. c. 1886

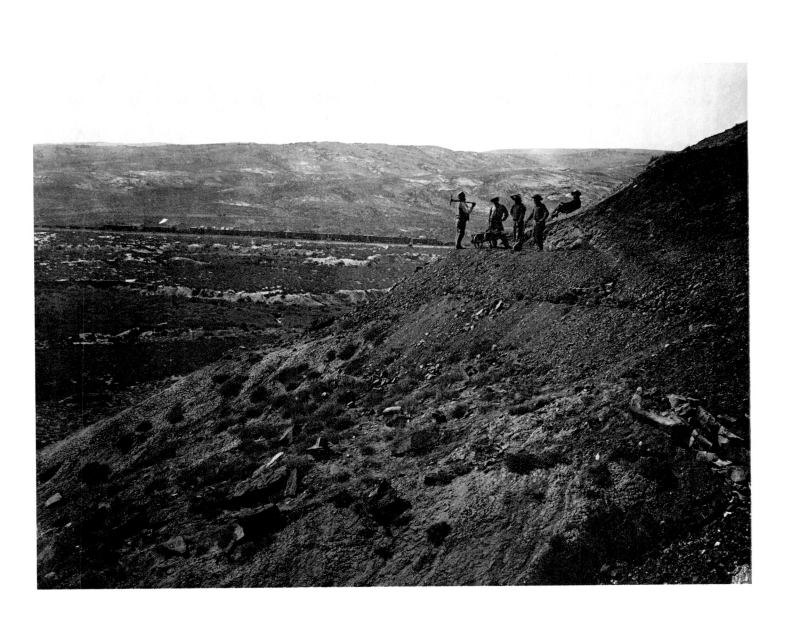

ANDREW JOSEPH RUSSELL

Valley of Bitter Creek from Coal Mines. 1868–69

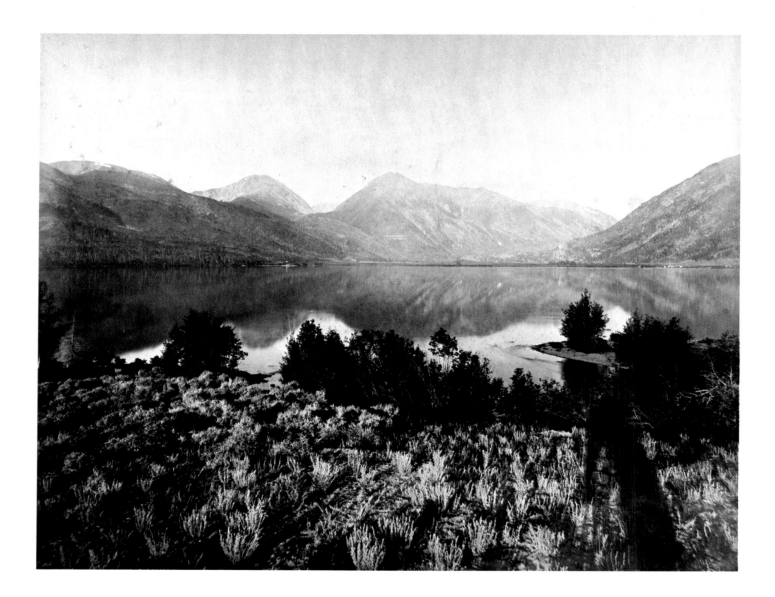

WILLIAM HENRY JACKSON

Upper Twin Lake, Colorado. 1875

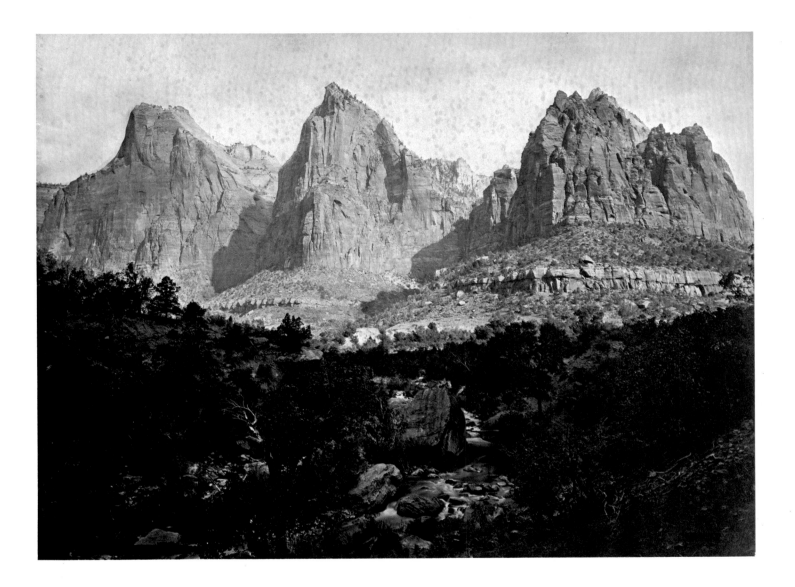

JOHN K. HILLERS

Untitled. 1872–78

23

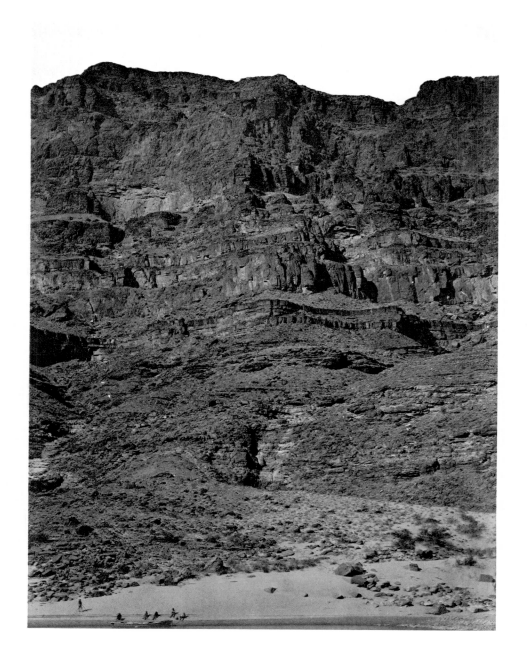

TIMOTHY H. O'SULLIVAN

Wall in the Grand Cañon, Colorado River. 1871

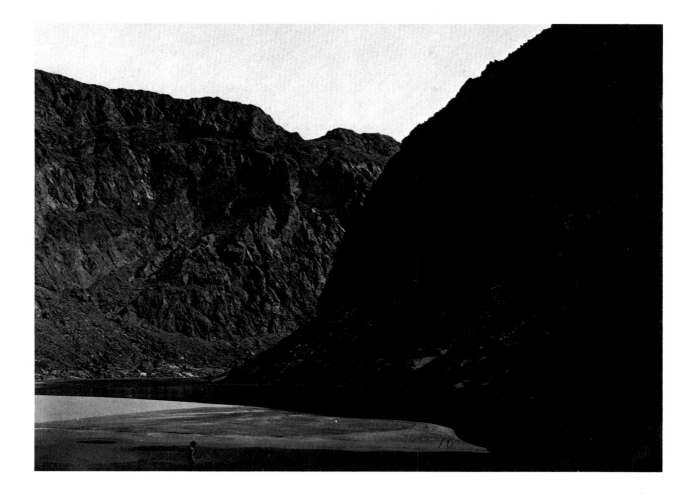

TIMOTHY O'SULLIVAN

Entrance to Black Cañon, Colorado River, from Above. 1871

25

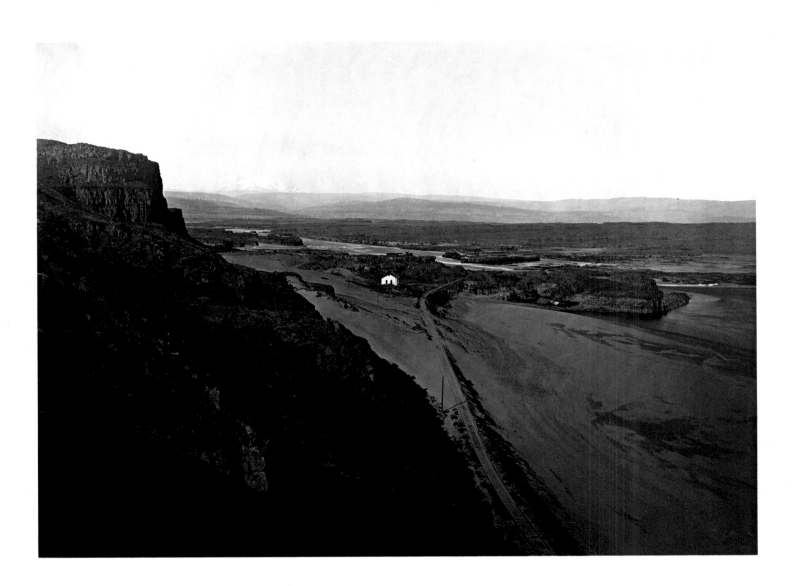

CARLETON E. WATKINS

The Dalles, Oregon. c. 1868

26

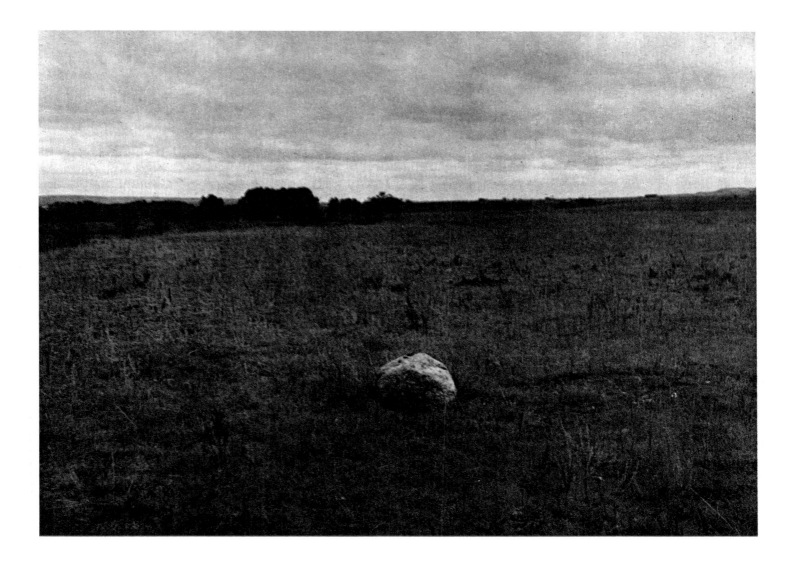

EDWARD SHERIFF CURTIS

The Mythic Stone—Hidatsa. 1908

27

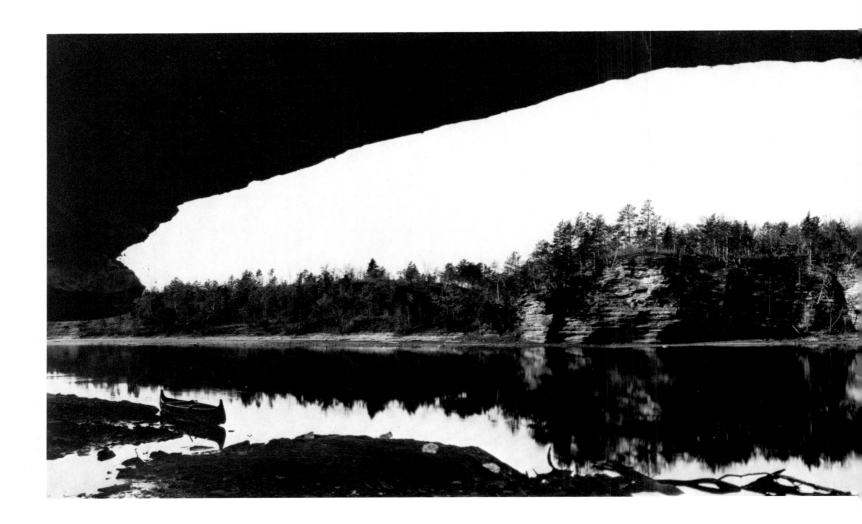

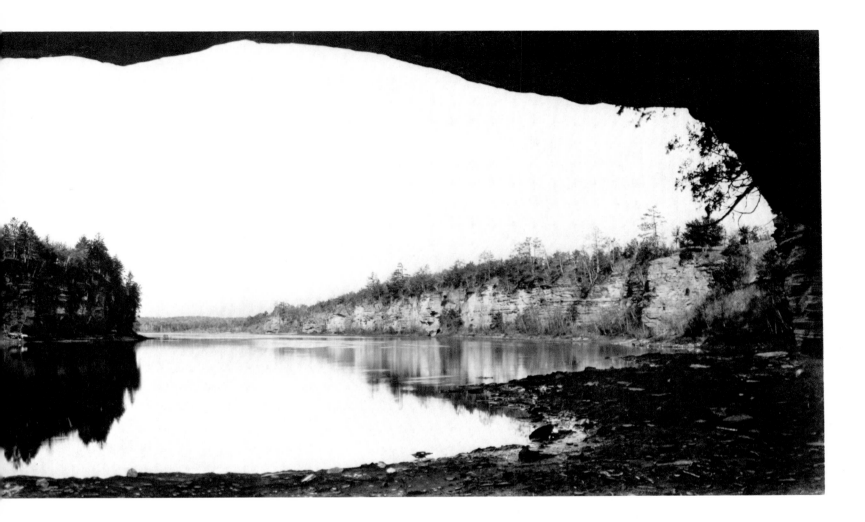

HENRY HAMILTON BENNETT

Panorama from the Overhanging Cliff, Wisconsin Dells. c. 1891

29

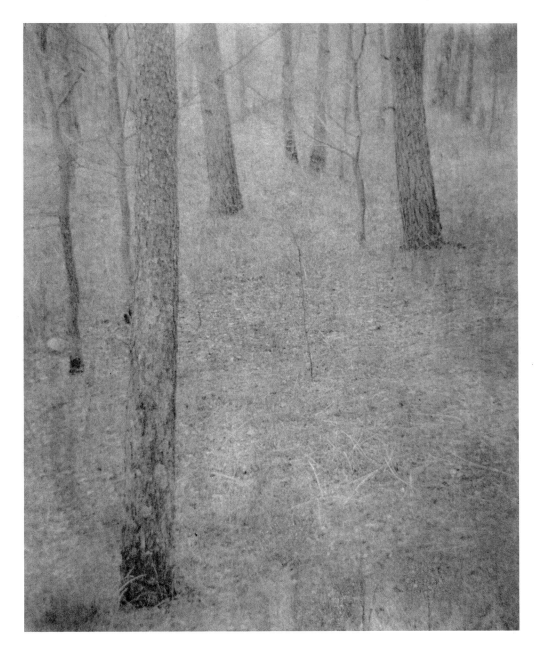

EDWARD STEICHEN

Farmer's Wood Lot. 1898

31

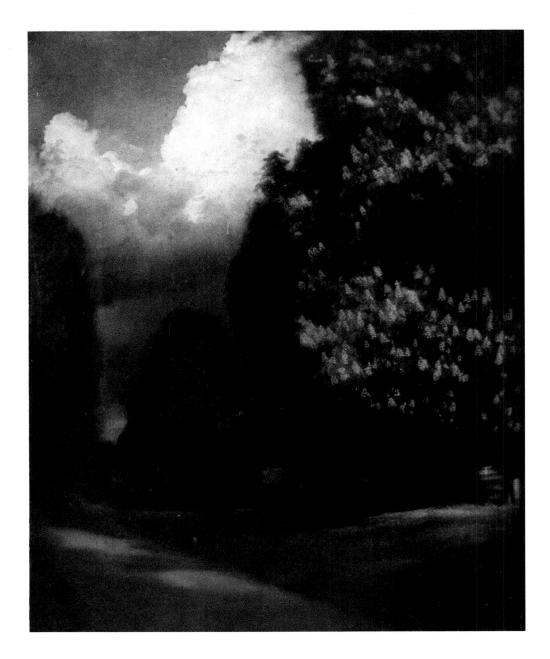

EDWARD STEICHEN

Horse-Chestnut Blossoms, Long Island. 1904

32

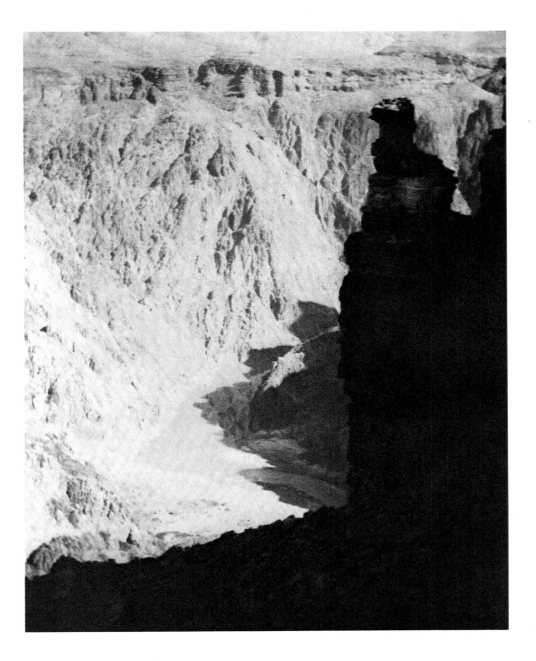

ALVIN LANGDON COBURN

Grand Canyon. c. 1911

33

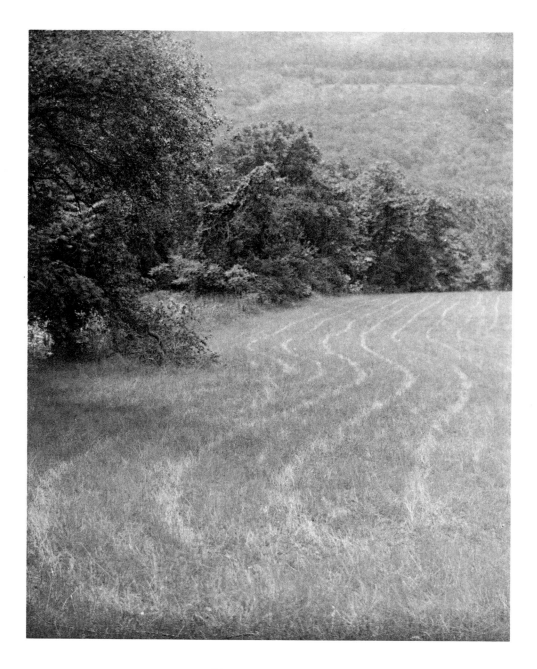

JOHN G. BULLOCK

Untitled. n.d.

34

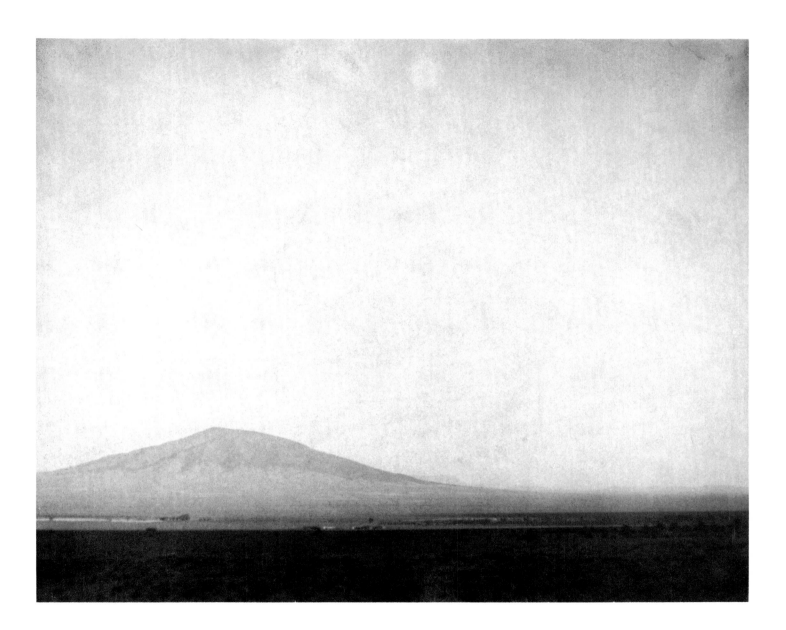

LAURA GILPIN

Mesa. 1921

35

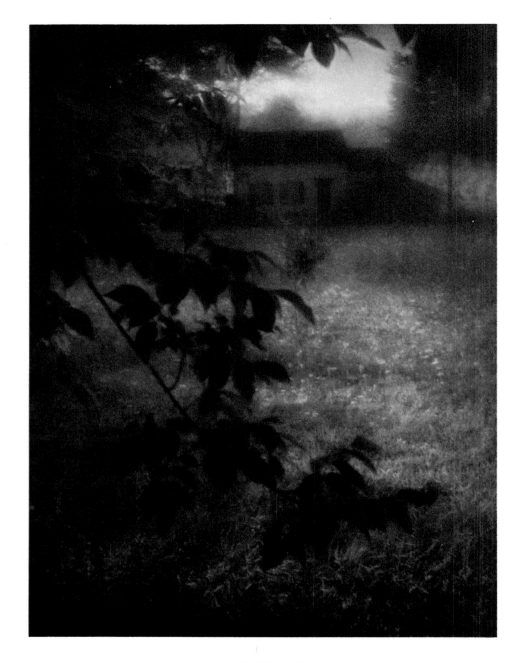

PAUL STRAND

Trees and White Farm House, Connecticut. 1915–16

36

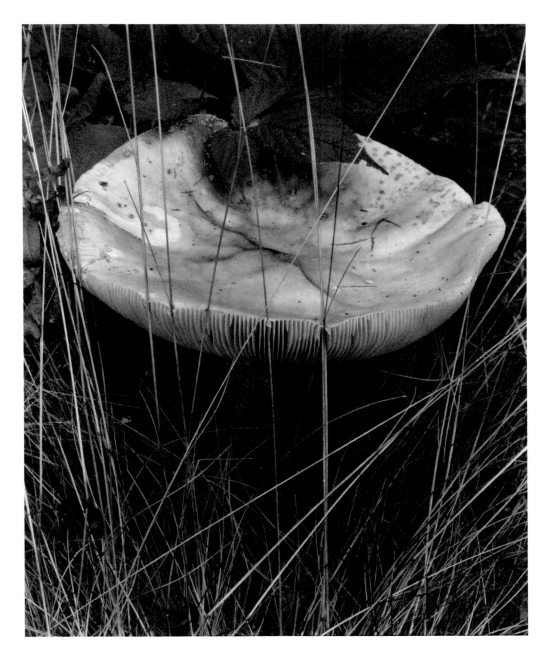

PAUL STRAND

Toadstool and Grasses, Georgetown, Maine. 1928

37

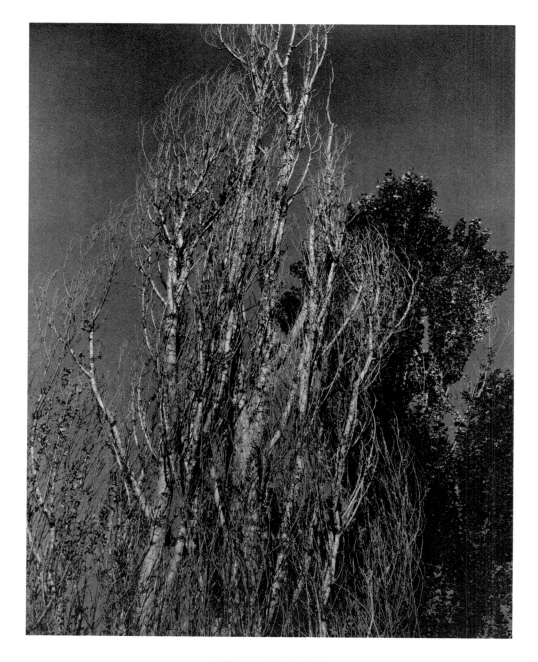

ALFRED STIEGLITZ

Lake George. 1932

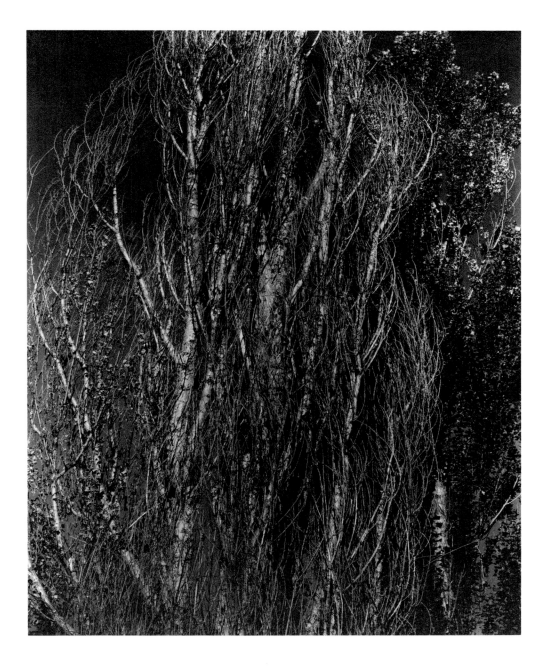

ALFRED STIEGLITZ

Lake George. 1932

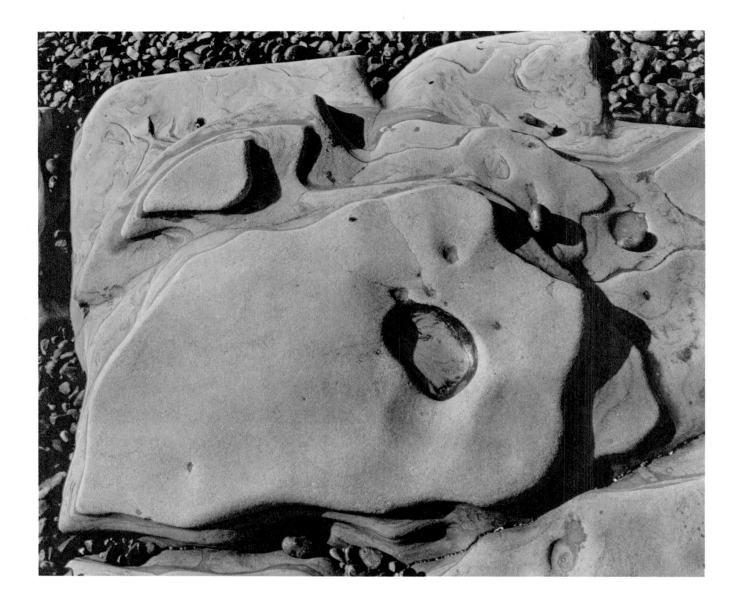

EDWARD WESTON

Eroded Rock, Point Lobos. 1930

40

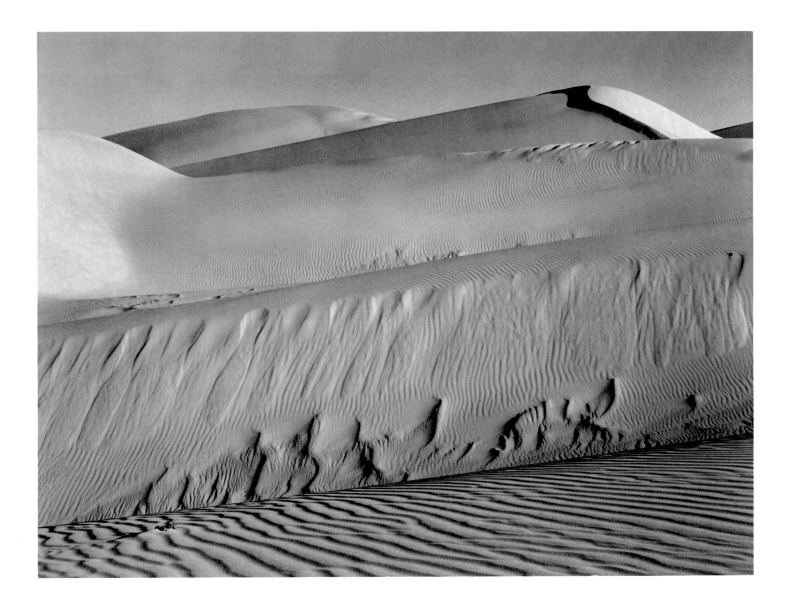

EDWARD WESTON

Sand Dunes, Oceano, California. 1936

41

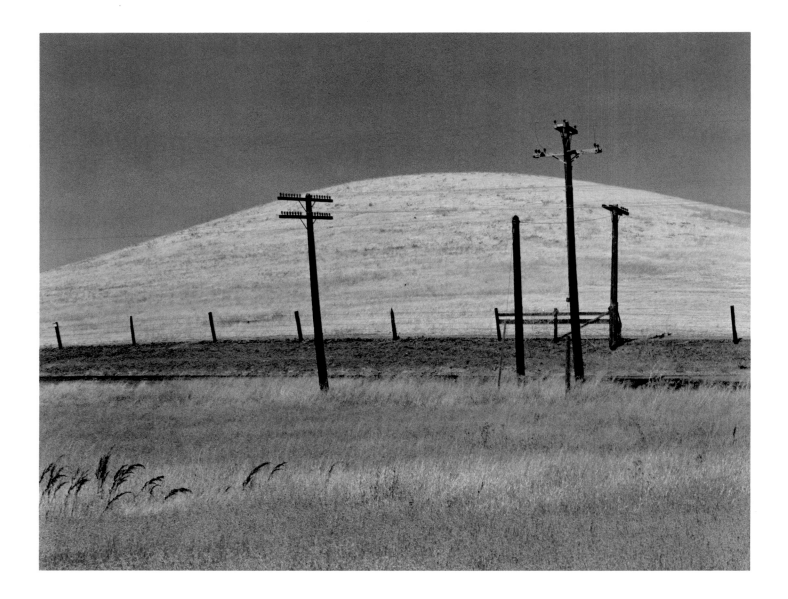

EDWARD WESTON

Solano County, California. 1937

42

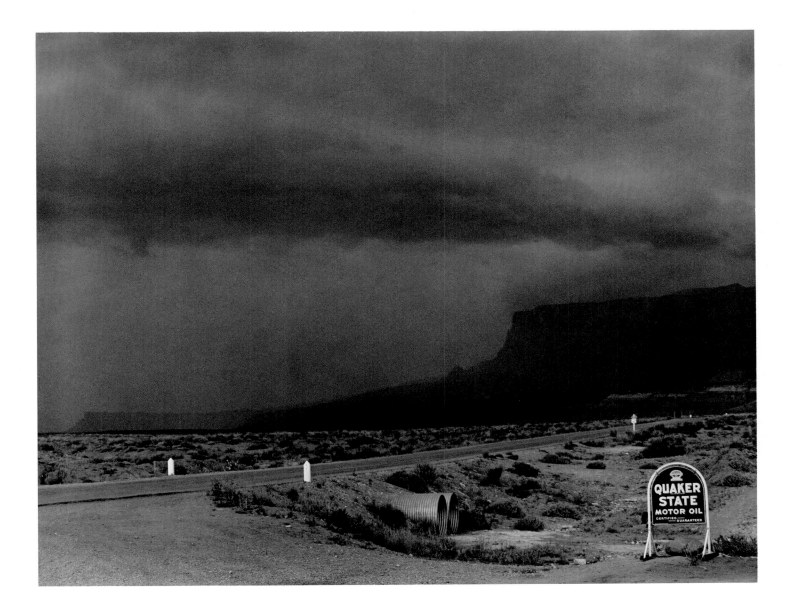

EDWARD WESTON

Quaker State Oil, Arizona. 1941

43

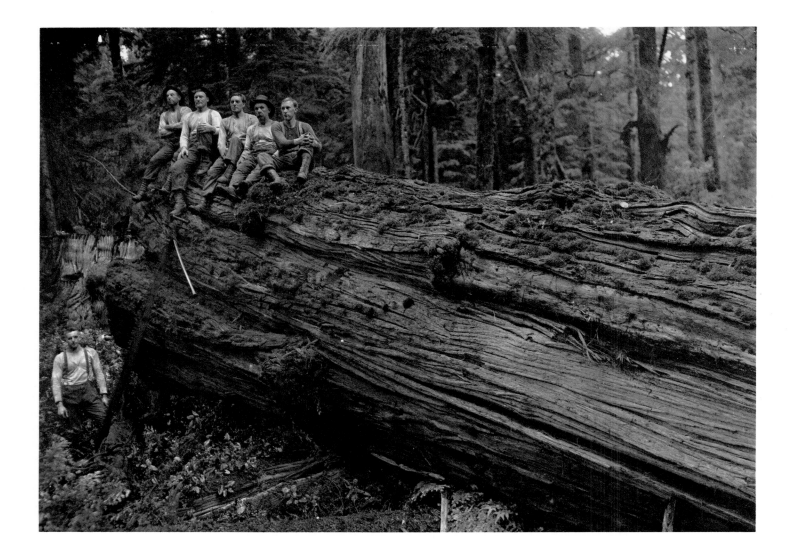

DARIUS KINSEY

Cedar. 1916

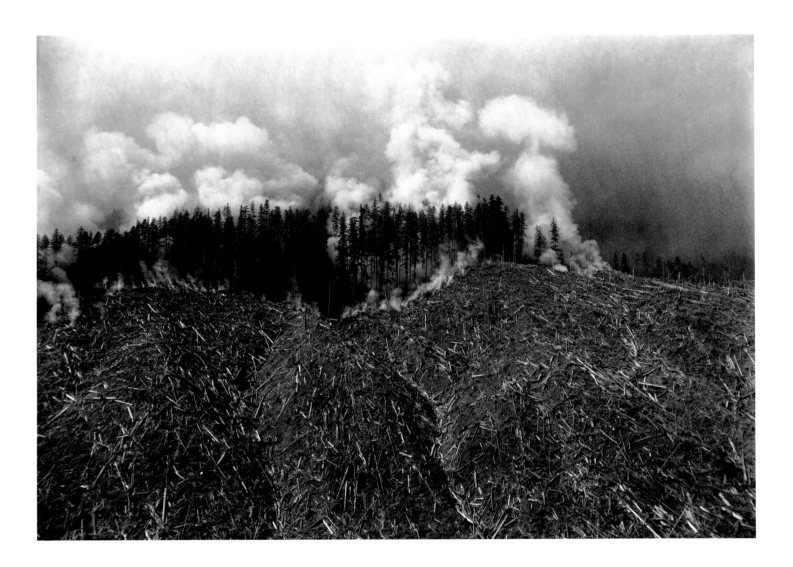

DARIUS KINSEY

Crescent Camp No. 1. c. 1922

45

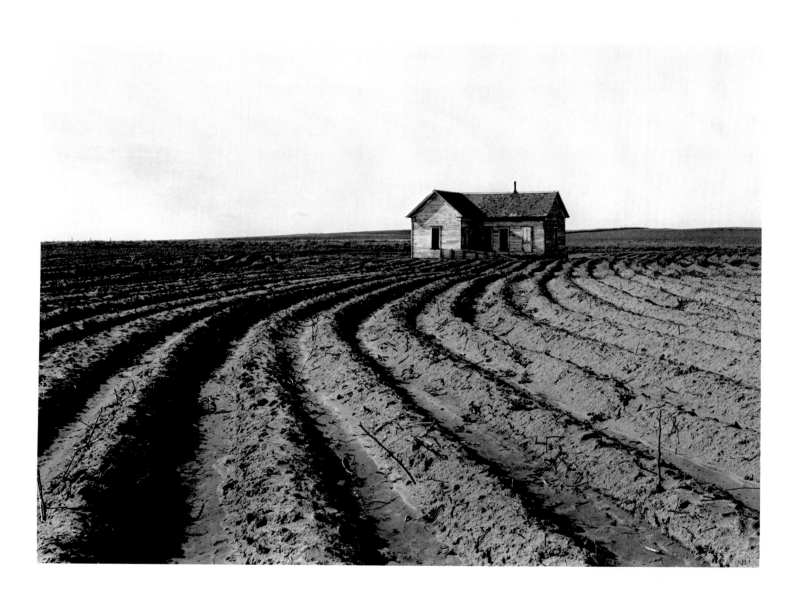

DOROTHEA LANGE

Tractored Out, Childress County, Texas. 1938

46

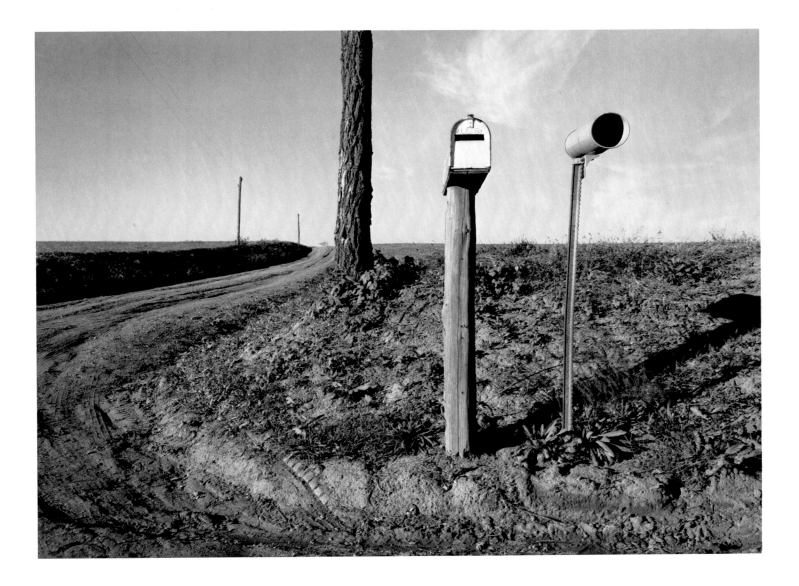

WRIGHT MORRIS

Untitled. 1947

47

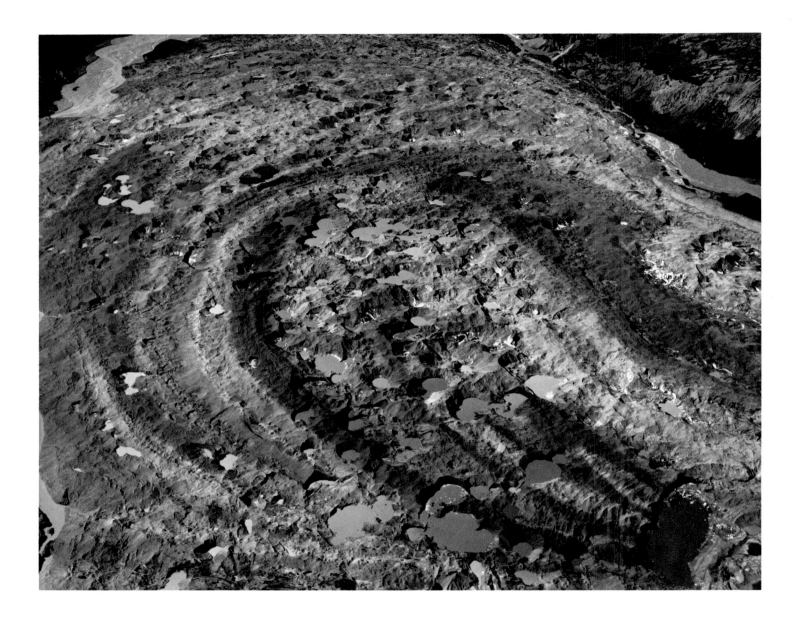

BRADFORD WASHBURN

Pitted Dead Surface of the Snout of Chitina Glacier on the Alaska-Canada Frontier. 1938

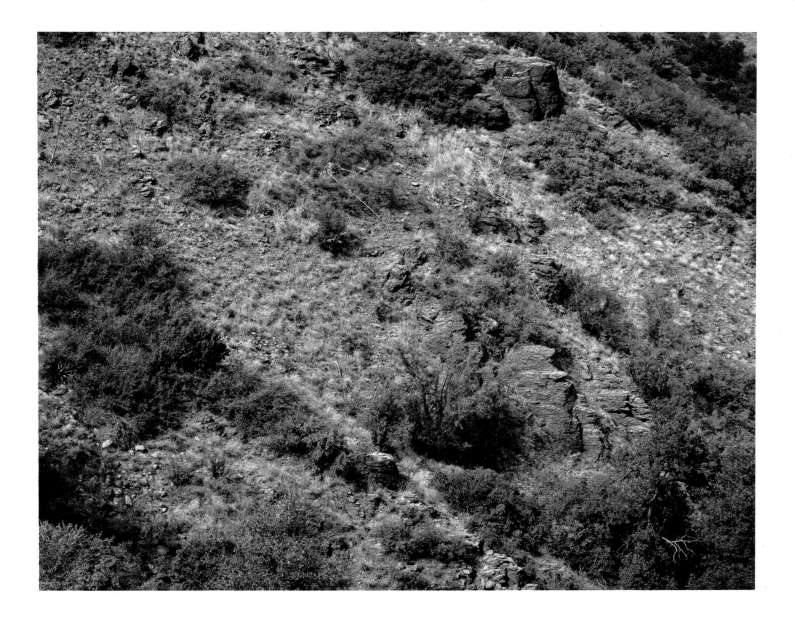

FREDERICK SOMMER

Arizona Landscape. 1943

49

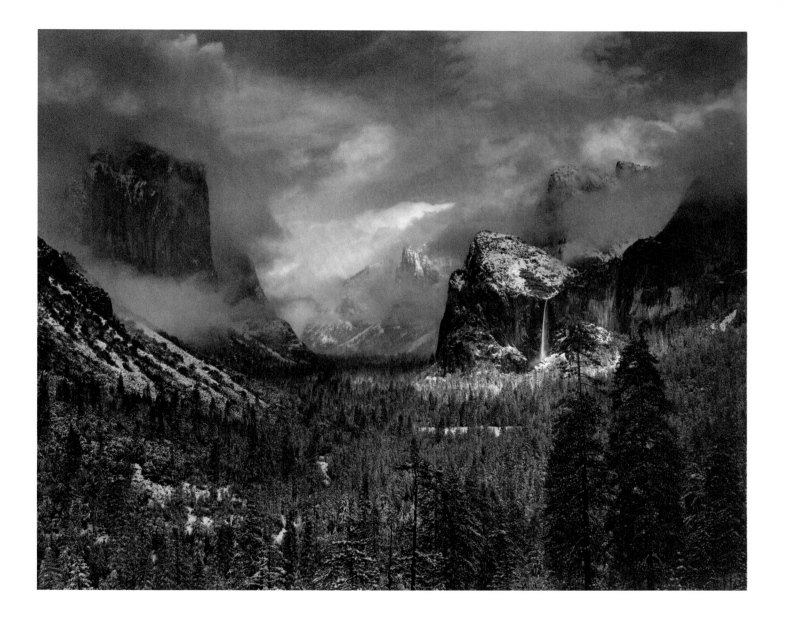

ANSEL ADAMS

Gates of the Valley, Winter Storm, Yosemite California. 1936

51

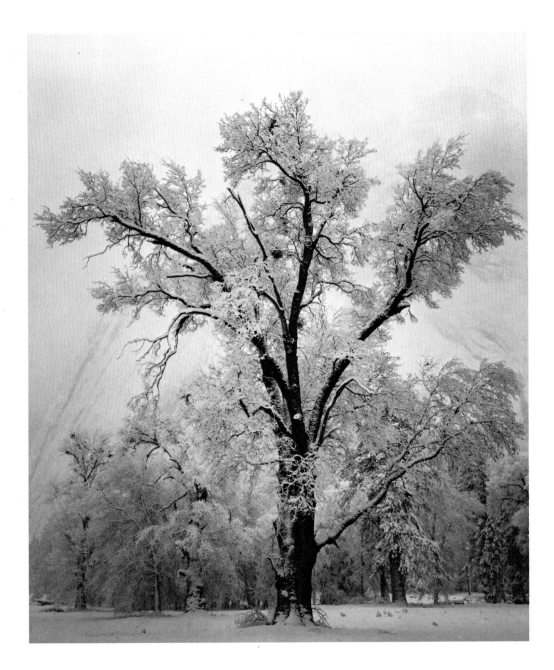

ANSEL ADAMS

Oak Tree, Snow Storm, Yosemite. 1948

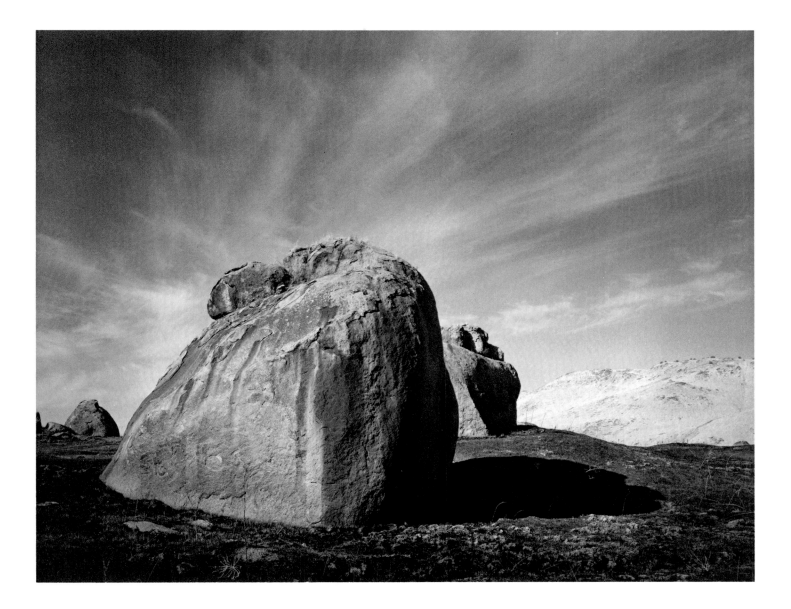

ANSEL ADAMS

Rocks, Sierra Foothills, California. c. 1938

53

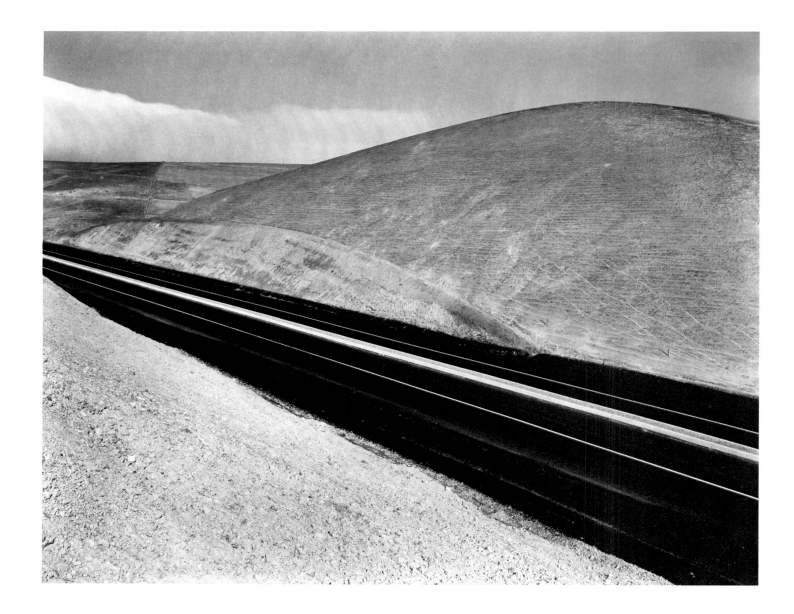

BRETT WESTON

New Highway North of Santa Fe. 1938

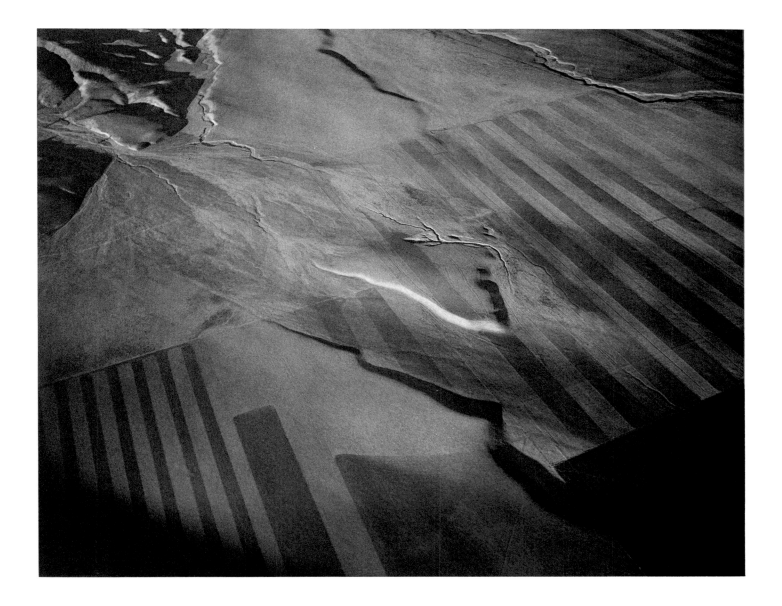

WILLIAM A. GARNETT

Erosion and Strip Farms. 1951

HARRY CALLAHAN

Weeds in Snow, Detroit. 1943

56

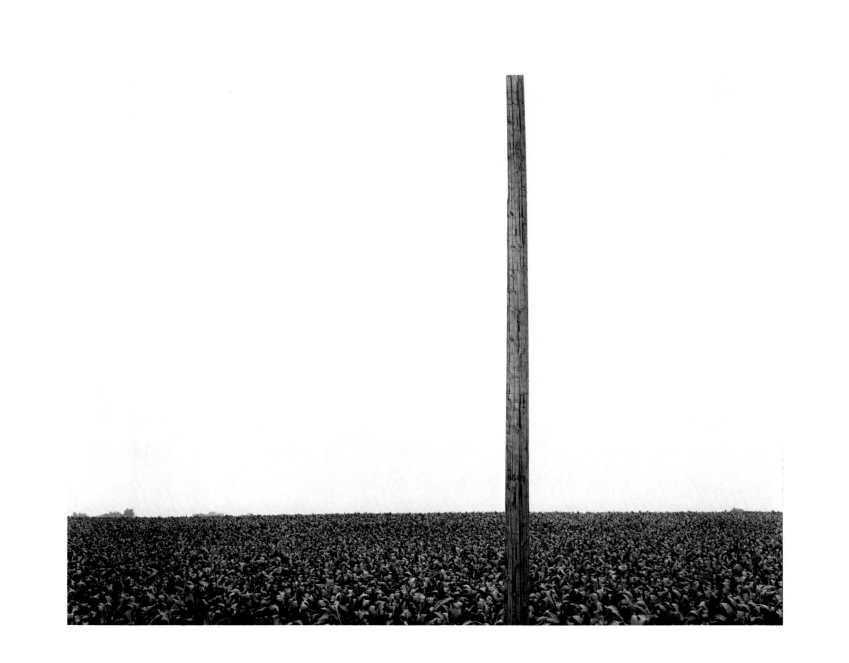

HARRY CALLAHAN

Environs of Chicago. c. 1952

57

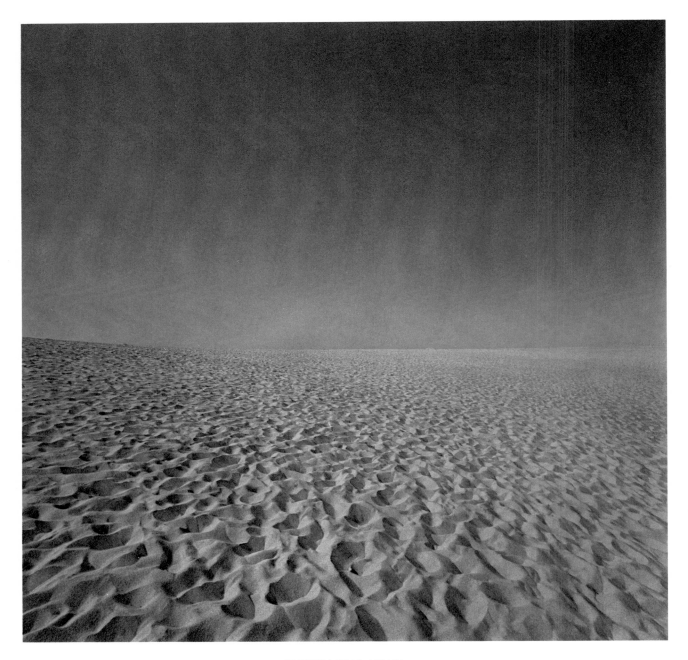

HARRY CALLAHAN

Cape Cod. 1972

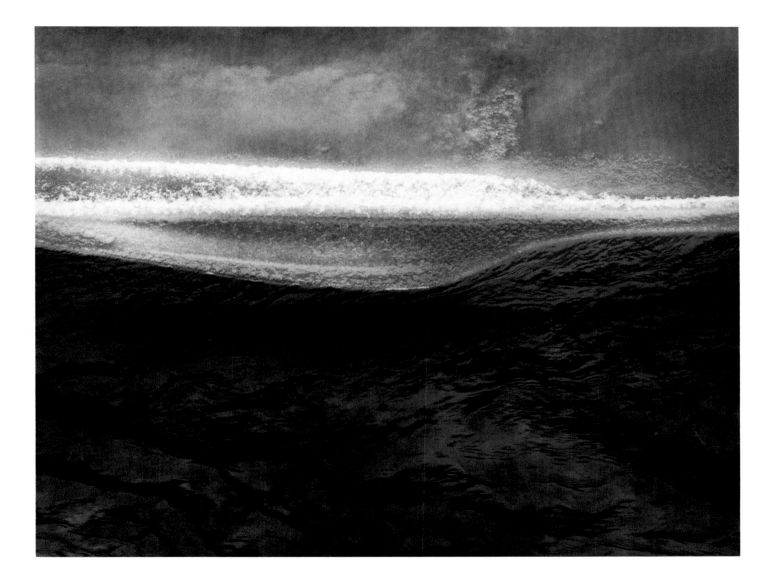

MINOR WHITE

Edge of Ice and Water. 1963

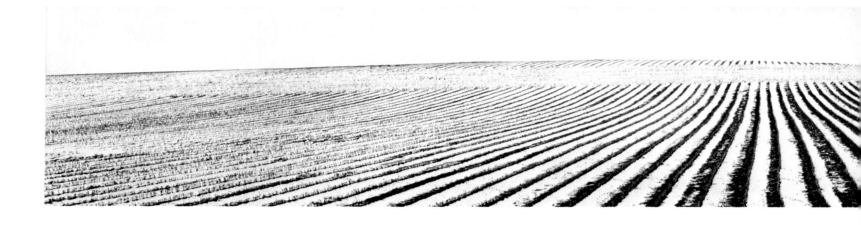

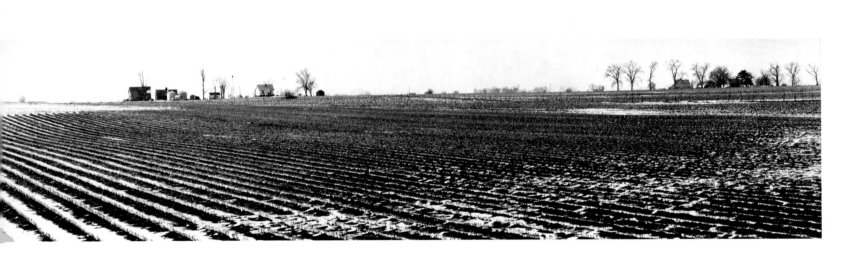

ART SINSABAUGH

Landscape No. 34. 1962

61

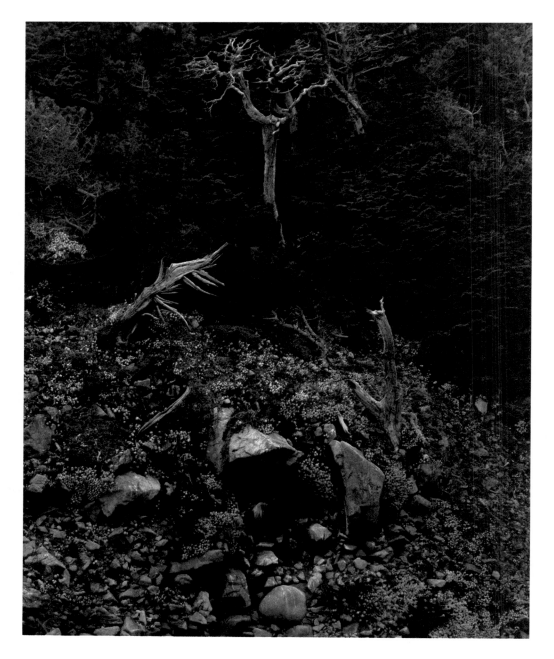

EDWARD WESTON

Point Lobos. 1946

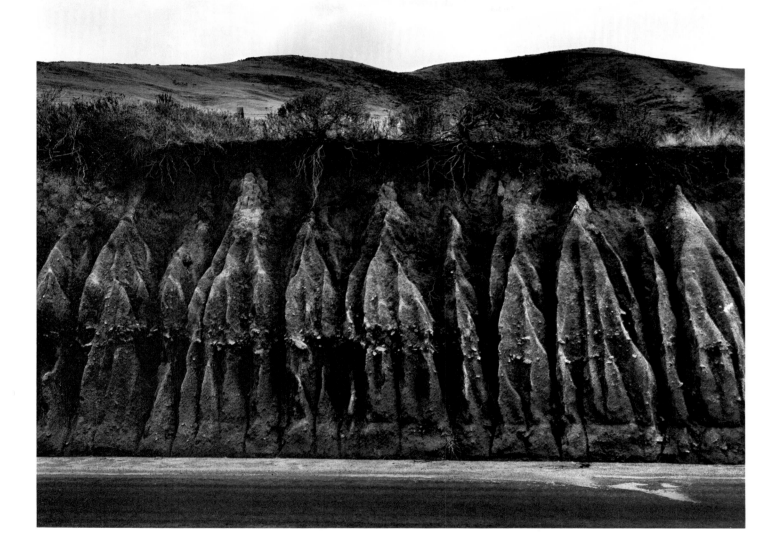

WYNN BULLOCK

Untitled. 1959

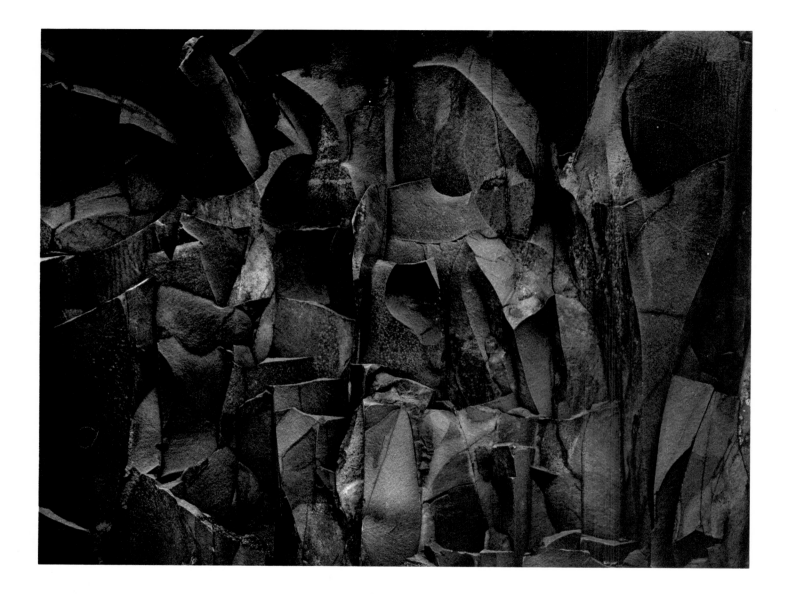

PAUL CAPONIGRO

Rock Wall, No. 2. 1959

64

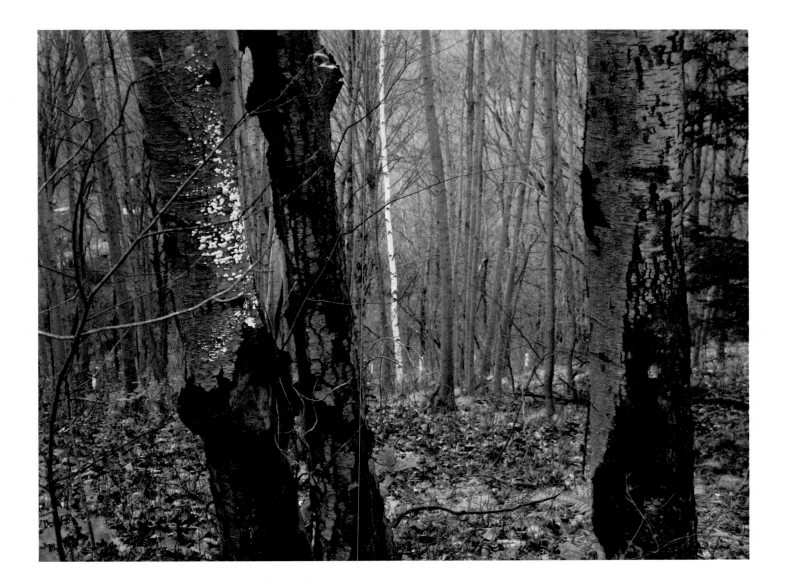

PAUL CAPONIGRO

Brewster Woods, New York. 1963

65

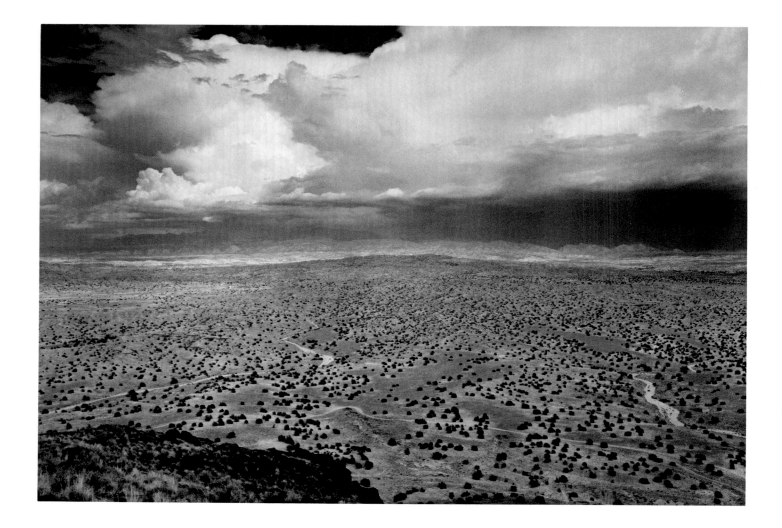

WILLIAM CLIFT

Landscape No. 2, New Mexico. 1978

66

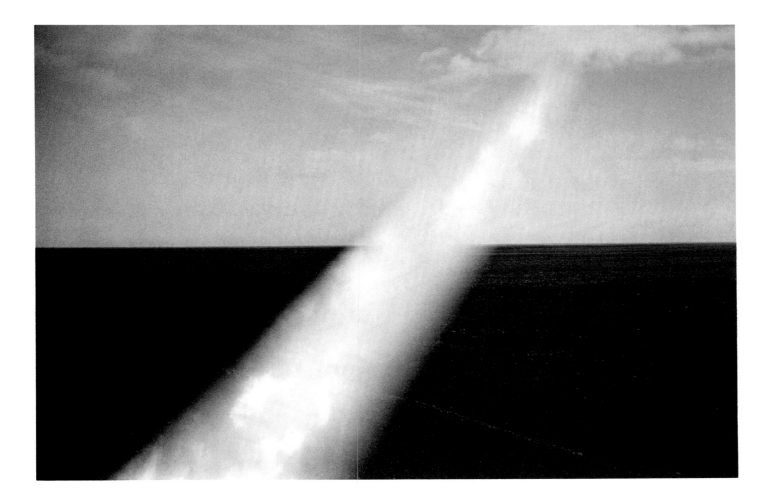

JOSEPH D. JACHNA

Iceland, South Coast. 1976

67

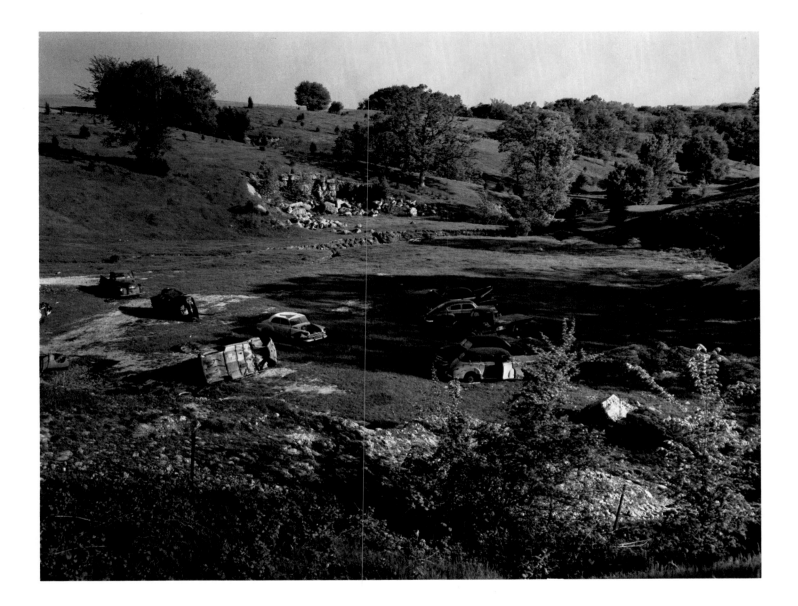

PAUL VANDERBILT

Beetown, Wisconsin. 1962

69

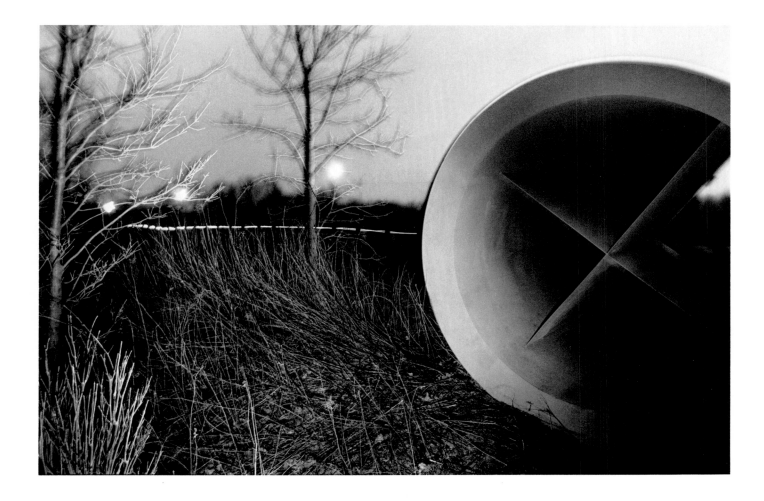

ROGER MERTIN

Rochester, New York. 1974

HENRY WESSEL, JR.

Untitled. 1971

71

BILL DANE

Pt. Richmond, California. 1972

LEE FRIEDLANDER

Gettysburg, Pennsylvania. 1974

73

ROBERT ADAMS

From Lookout Mountain — Smog, No. 7. 1970

74

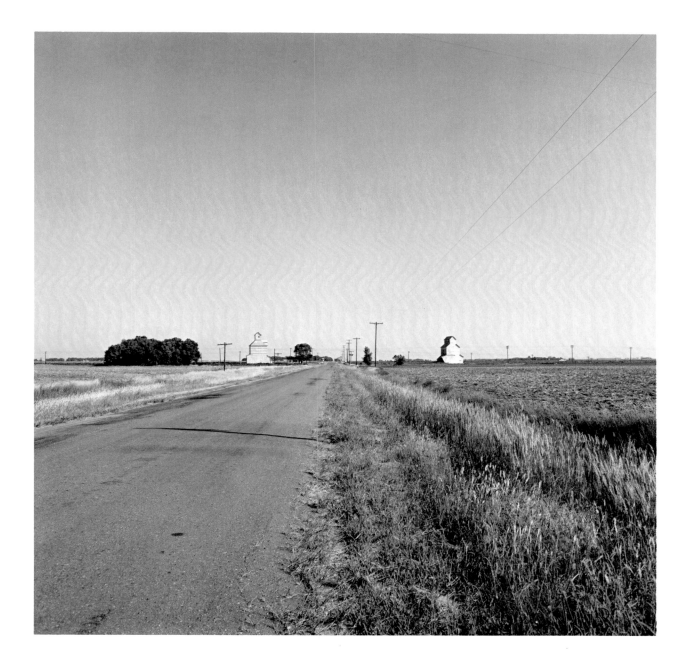

FRANK GOHLKE

Grain Elevators — Near Kinsley, Kansas. 1973

CATALOG

All photographs are from the Collection of The Museum of Modern Art.